WHITLEY BAY AND SEATON SLUICE

HISTORY TOUR

The book is dedicated to Pam, Surts, Val, Steve, Anne and Jeff.
All royalties from the sale of this book will go to St Oswald's Hospice.

Front cover image shows Front Street, Whitley Bay, *c.* 1918. Back cover image shows Seaton Sluice Harbour *c.* 1920

First published 2017

Amberley Publishing
The Hill, Stroud,
Gloucestershire, GL5 4EP
www.amberley-books.com

Copyright © Ken Hutchinson, 2017
Map contains Ordnance Survey data
© Crown copyright and database right
[2017]

The right of Ken Hutchinson to be
identified as the Author of this work
has been asserted in accordance with
the Copyrights, Designs and Patents
Act 1988.

ISBN 978 1 4456 6676 1 (print)
ISBN 978 1 4456 6677 8 (ebook)

British Library Cataloguing in
Publication Data.
A catalogue record for this book is
available from the British Library.

Origination by Amberley Publishing.
Printed in Great Britain.

INTRODUCTION

Whitley Bay and Seaton Sluice both developed from small villages and have seen many changes over the years. They are linked by a seafront path along the north-east coastline that leads past the landmark of St Mary's Lighthouse.

Whitley Bay

The name of Whitley is thought to come from early Angle settlers who referred to it as 'White Lea' or 'pasture land'. The first records of the name go back as far as 1116 and Ralph de Whitley was the owner in 1225. It was owned by the prior of Tynemouth until 1539 and from 1750 by the Duke of Northumberland and others. Whitley started life as a small agricultural village, centred on what is now the present town centre, between St Paul's Church and Victoria Terrace. The short main street was called Front Street with the large house and grounds of Whitley Hall on the south side and the large Whitley House and the Victoria Hotel on the north side, together with a number of inn's, modest cottages, a forge and other businesses making up the village.

From the 1670s coal mining took place in areas around the village, as well as quarries dating from 1684 at Marden, and 1817 at Hill Heads. St Paul's Church was built to the west of the village in 1864 to serve the Cullercoats parish when the Tynemouth parish was divided in two.

When the railways reached Whitley Bay in the late 1800s, the town developed rapidly as a holiday destination both for Tyneside and beyond.

It also became a popular residential commuter town for Newcastle. A large number of impressive terraced houses were built by the wealthy, both close to the railway station and with views over the sea, as well as hotels, guest houses, shops and visitor attractions.

The town was called Whitley Bay from 1901 following an unfortunate event when William Oliver died in Scotland and was sent back to Whitley by train to be buried at St Paul's but ended up in Whitby.

The famous iconic Spanish City Dome was built in 1910 and formed part of the Whitley Bay Pleasure Gardens that became a magnet for holidaymakers from Scotland as well as locals on Tyneside. This continued during the first half of the twentieth century and Whitley Bay became one of the North East's premier holiday resorts until the 1970s, when holidays abroad became popular.

Seaton Sluice

The name of Seaton was derived from a settlement (*ton*) beside the sea. It was situated around half a mile north of Hartley village and formed part of the old manor or administrative area. Hartley is first recorded in 1097 and the local landowning family who had come across with William the Conqueror, the De la Vals, adopted the name Seaton for the nearby settlement of Seaton Delaval. Seaton became Seaton Sluice in the 1660s when Sir Ralph Deleval erected sluice gates at Seaton to block the Seaton Burn, in order to hold water back. The water was then released to sluice the sediment in the harbour to improve navigation for ships exporting coal and salt from there.

The harbour was further developed in the 1760s when Sir John Delaval made the impressive 'cut' through solid rock at Seaton Sluice to provide a twenty-four-hour loading facility in the harbour to export coal, salt and bottles from a major new bottle works he built on the site with his brother Thomas.

Industry dominated the town for the next century and the Royal Hartley Bottle Works, developed by the Delaval family, produced over 1 million bottles a year and almost all the occupants worked for the Delaval family. They also lived in houses built by the Delaval's, shopped in their shops and drank beer in their pubs, which had been brewed in the town's own brewery. A doctor was also available for the workers.

The bottle works closed in 1872 and exports of coal stopped following the Hartley Pit Disaster in 1862. Trade in the harbour declined and Blyth developed to be the principal port. The six landmark bottle cone furnaces were demolished in 1897. The town continued to provide labour for the local collieries.

Seaton Sluice has now extended to the adjoining village of Hartley, later to be called Old Hartley, to distinguish it from the village of New Hartley built around a new colliery developed in 1850 around 3 miles inland to the north-west. Hartley village was an agricultural village between Whitley and Seaton Sluice villages. Holywell Dene once had 200 people living within it but is now almost deserted – it is now an attractive steep-sided wooded valley and important wildlife habitat extending inland from Seaton Sluice and forming the southern boundary of Seaton Delaval Hall estates. Seaton Delaval Hall was designed by John Vanbrugh for Admiral George Delaval and built between 1718 and 1728. The National Trust bought the property in 2009.

Immediately to the west of Seaton Delaval Hall is the ancient Church of Our Lady built in 1102 as a private church for the Delaval family, but has been the parish church since 1891. To the west of the church was a small settlement comprising of one street and this was the original Seaton village that was cleared in 1959.

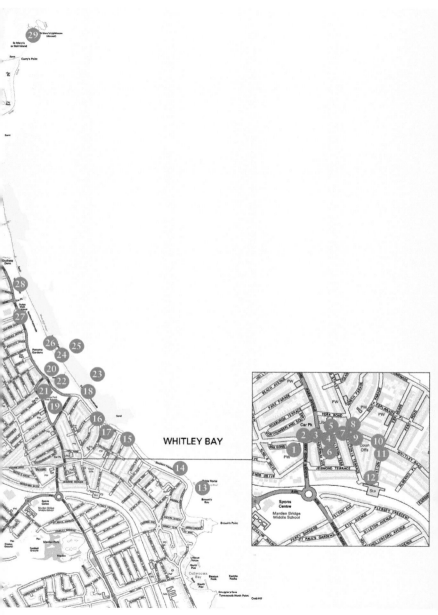

WHITLEY BAY

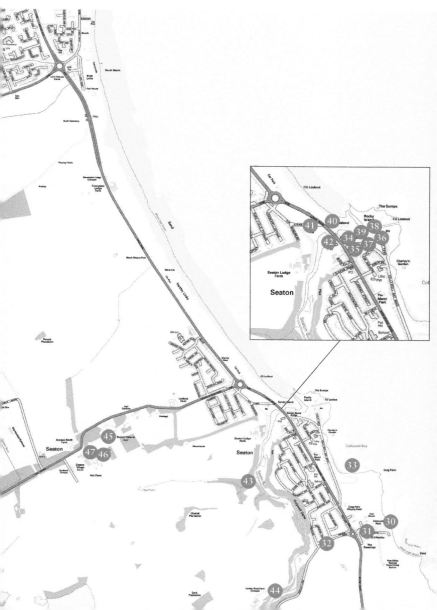

1. ST PAUL'S CHURCH, *c.* 1911

St Paul's Church was built in 1864 to serve the parish of Cullercoats including the village of Whitley and the surrounding settlements of Whitleyhill Heads and Monkseaton. It was designed by Anthony Salvin for the Duke of Northumberland and was built at the western end of the village. A new hall was added in 2000.

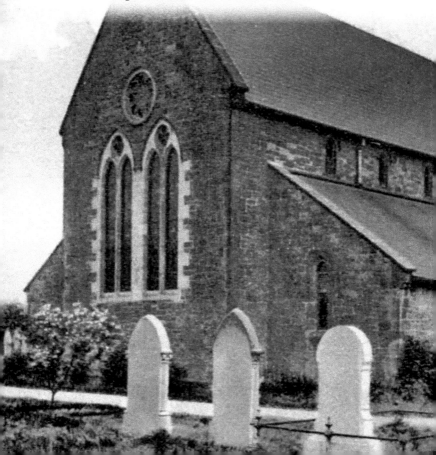

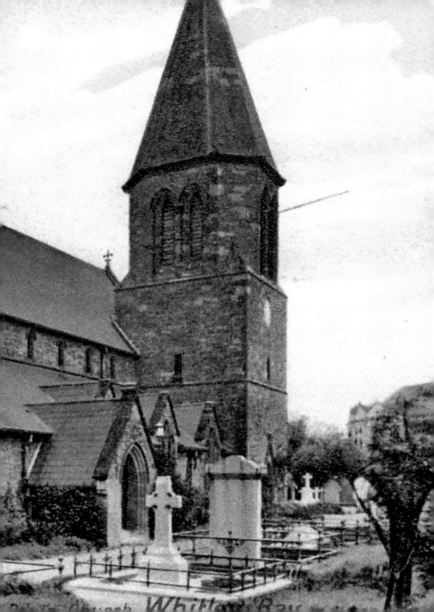

Whitley Bay

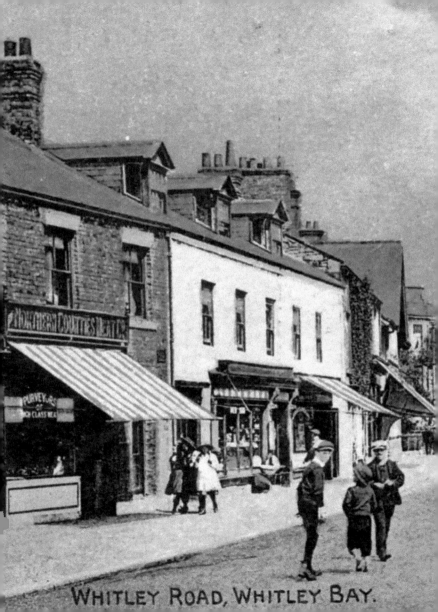

WHITLEY ROAD, WHITLEY BAY.

2. WHITLEY VILLAGE, *c.* 1907, LOOKING EAST

The branch store of North Shields Industrial Society, built in 1902, is on the right. On the left is the Ship Inn at the end of a row of shops built into former houses called Rookery View, as they overlooked the trees and rooks nests in Whitley Hall. The large building in the distance is the Council Office, built in 1902 at the edge of Whitley village.

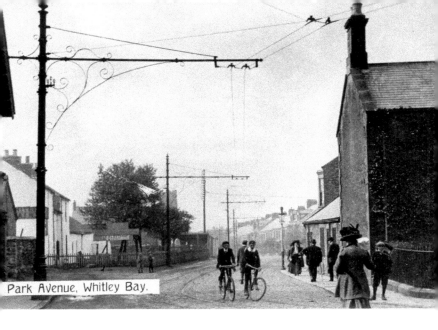

Park Avenue, Whitley Bay.

3. PARK AVENUE FROM VILLAGE, 1905

The Ship Inn (rebuilt in 1895), is on the left and Ivy House on the right, either side of Park Avenue, which led down to Whitley Park Hall. The white building is Whitley Dairy, which was replaced by the post office in 1925, and further north by the bus station in 1936. Above the bus station was the first Whitley Bay Library in 1939 and later the Sands Club. The present shopping centre, built in the 1990s, now occupies this area.

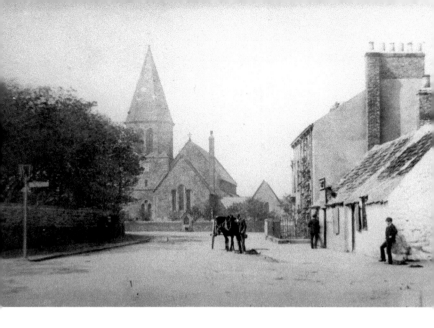

4. FRONT STREET, *c.* 1890, WEST END

The trees are situated in the grounds of Whitley Hall behind the stone boundary wall. The white building on the right is the original Ship Inn with the former Wesleyan chapel behind – this later became Johnson's refreshment rooms. Rookery View was beyond that and the Fat Ox public house is out of view. St Paul's Church is in the background.

5. FRONT STREET, *c.* 1908, LOOKING EAST

The trees on the right were cut down in 1922 to provide a forecourt to the shops and bank built behind them on the site of Whitley Hall. On the north side of Front Street there are trees in the gardens of Ivy House. Next door is Belvedere House, built around 1800, and beyond that is Whitley House, which was built in 1830. The present white-faced Belvedere buildings were built around 1926 on the site of Ivy House. In the distance Central Buildings dominate the corner of Whitley Road and South Parade.

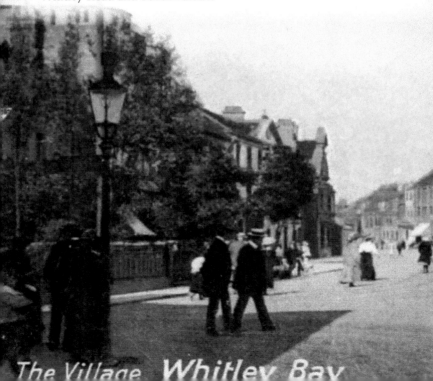

The Village Whitley Bay

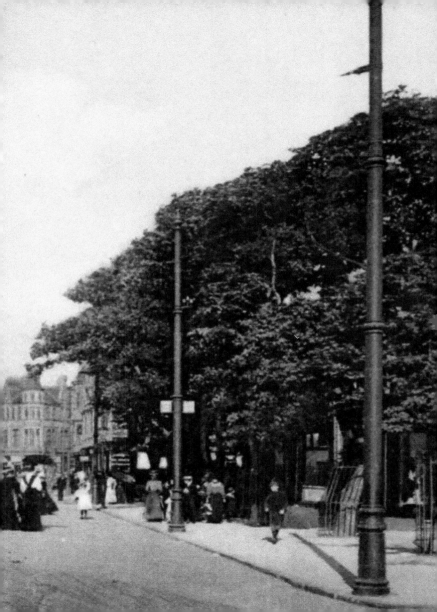

6. WHITLEY HALL, *c.* 1894

Whitley Hall and its grounds occupied the south side of Whitley village until 1900 when it was demolished. It was set back from Front Street with its main aspect facing south and had a stone wall backing on to Front Street with mature trees between. It was built around 1760 by Henry Hudson and sold to the Duke of Northumberland in 1817, who later developed this site and other areas of Whitley Bay.

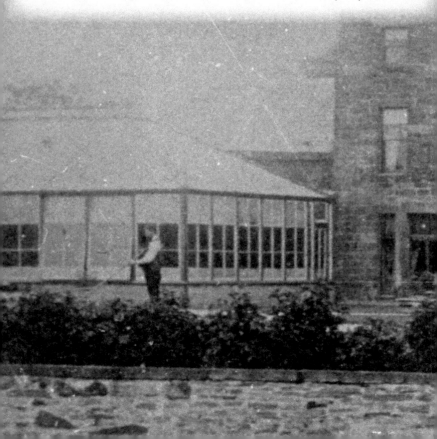

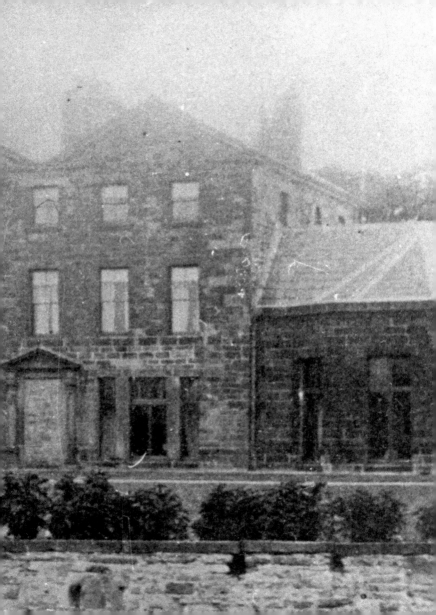

7. WHITLEY VILLAGE, *c.* 1905, LOOKING WEST

The Council Chamber on the right was built on the site of a former cottage and opened on 1 June 1901 for the Whitley and Monkseaton Urban District Council. From 1922 some of the ground floor was let as shops and Woolworths built a shop next door in 1927. In 1955 Woolworths redeveloped both sites to form a large store, now B & M. The present Victoria Hotel was originally called Whitley Park Hotel until it was rebuilt in 1870 and further extended in 1890. Beyond that is Whitley House, which was replaced by the Coliseum Theatre in 1910, then ABC Cinema in 1923.

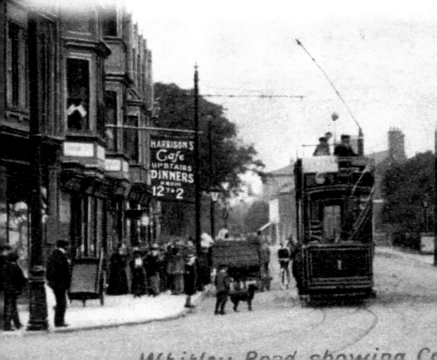

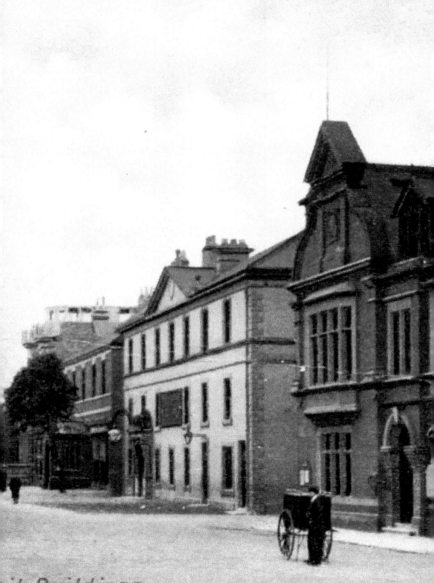

il Buildings

8. FRONT STREET, *c.* 1899, LOOKING WEST

Charlton's Smithy (blacksmiths) formed the east end of Whitley village for many years but, as it stood in the middle of the future Whitley Road leading from Station Road, it was demolished in 1901. The building on the left was the lodge of Whitley Hall that was replaced by the present shops built by Henry Septimus Proud in 1897, with more shops built beyond as far as Clifton Terrace. The Ship Inn can be seen in the distance.

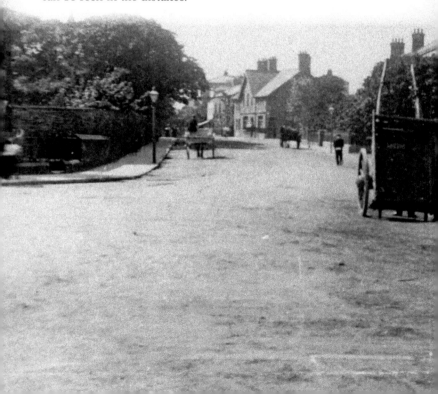

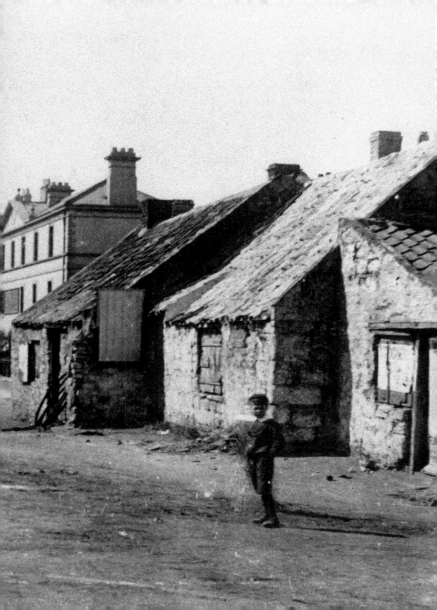

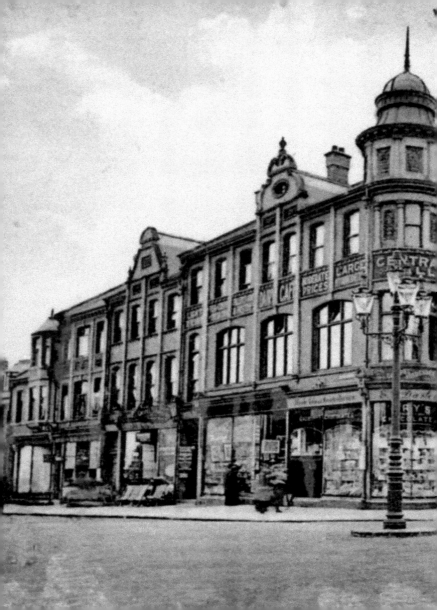

9. WHITLEY ROAD, *c.* 1910, LOOKING EAST

Central Buildings were built around 1900, approximately the same time as the Imperial Buildings on the opposite corner. The grand Edwardian architecture reflects the growing confidence in the development of the town as a commercial centre to serve the rapidly expanding town. This postcard dates from around 1910. Povesi's Assembly Rooms were just along Whitley Road on the north side.

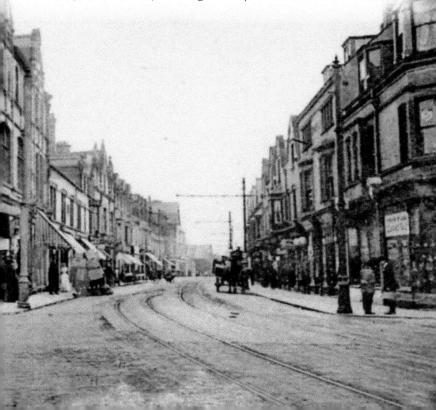

10. WHITLEY ROAD, *c.* 1905, LOOKING WEST

This postcard dates from before 1905 and shows some of the first purpose-built shops and commercial premises in the newly expanding town centre of Whitley Bay. It led directly from the original Whitley village and the Council Buildings can be seen in the background. The trams from Tynemouth operated from 1901 to Front Street, then to the Links in 1904.

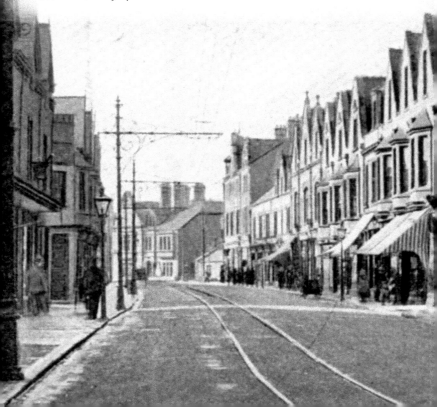

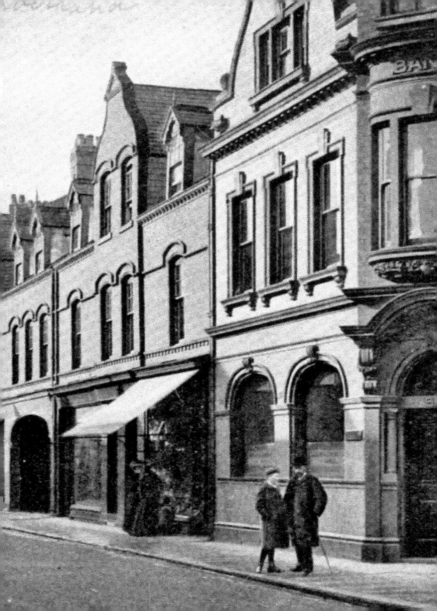

11. STATION ROAD, *c.* 1905, LOOKING NORTH

This image of Station Road around 1905 shows the original 1882 station in the distance, which was a simple low-level building with no great ornamentation. It was built at a time when Whitley was just a small village and the coastline cliffs and sands were untouched by visitors. By 1908 it was felt that Whitley Bay needed to have a new station to deal with the growing number of visitors.

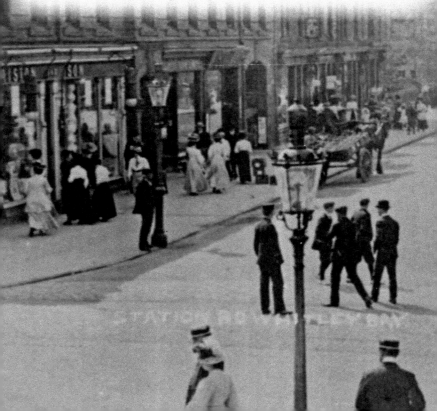

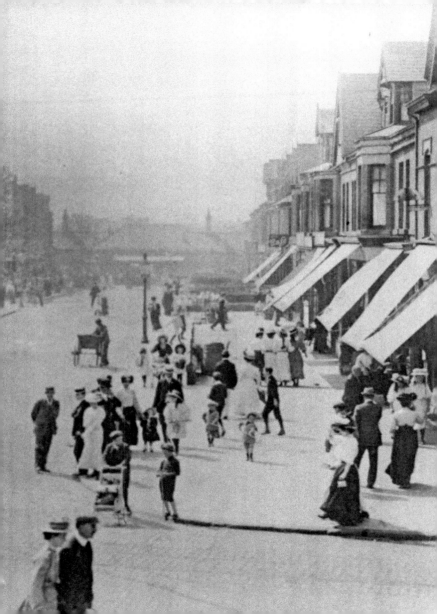

12. WHITLEY BAY STATION, *c.* 1910

The new station was opened in 1910 and was built behind the original one, leaving an impressive open space when the first station was demolished. The grand design, dominated by the landmark clock tower, reflected the growing importance of the holiday resort. It was designed by William Bell. Outside the station is the rare K4 red telephone box, with integral postbox and stamp sales machine, now a listed building (*see* inset).

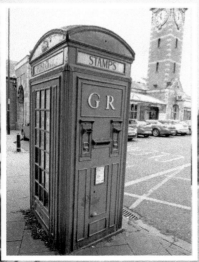

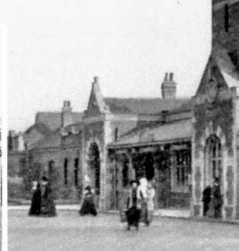

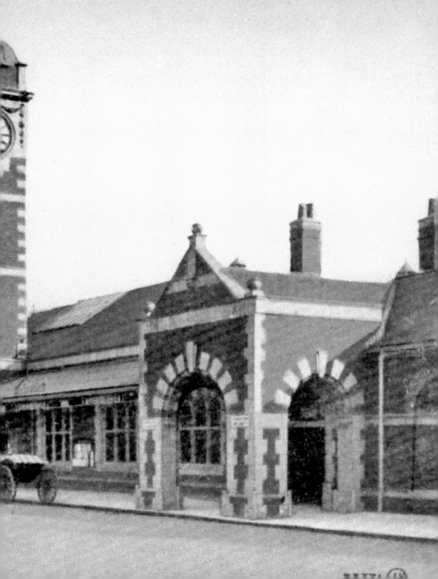

Station Square, Whitley Bay

13. TABLE ROCKS BATHING POOL, *c.* 1909

As the numbers of people swimming in the sea grew steadily, there was a number of accidents culminating in the loss of life due to dangerous currents, so it was decided to create a safe swimming pool at Table Rocks in 1894. The pool utilised a natural hollow feature in the rocks and an artificial dam was built on one side to create a swimming pool. The pool was doubled in size in 1908. (*Inset*: the pool in 1912.)

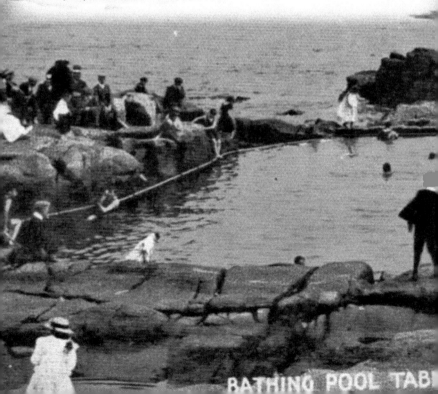

BATHING POOL TABI

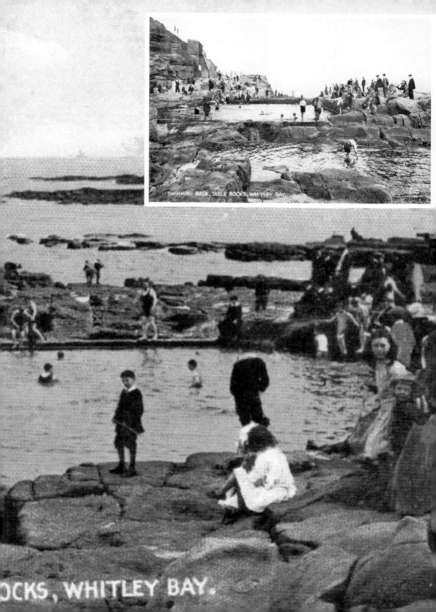

SWIMMING BATH, TABLE ROCKS, WHITLEY BAY.

OCKS, WHITLEY BAY.

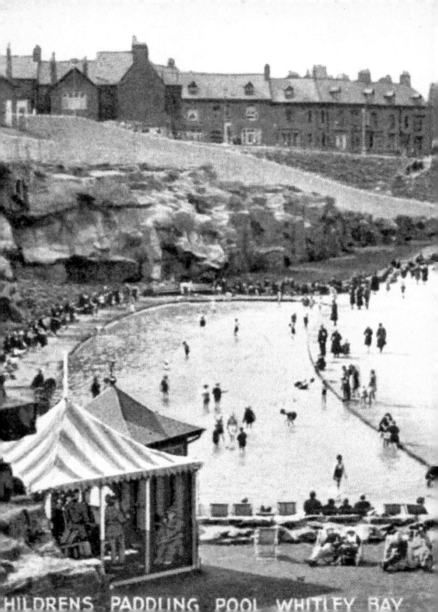

HILDRENS PADDLING POOL WHITLEY BAY

14. SOUTHERN LOWER PROMENADE, *c.* 1930

In the 1930s the Southern Lower Promenade was redeveloped from the former informal gardens known as Muir Gardens or Victoria Gardens, developed in the 1890s to produce a large children's paddling pool and other amenities for holidaymakers.

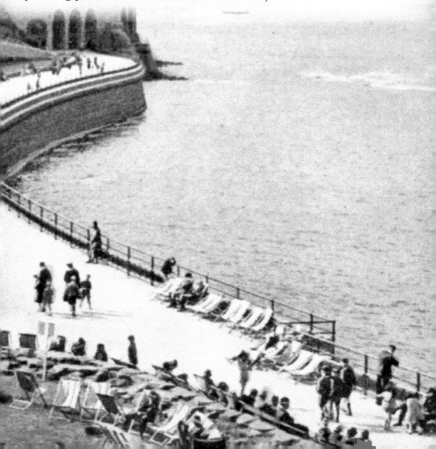

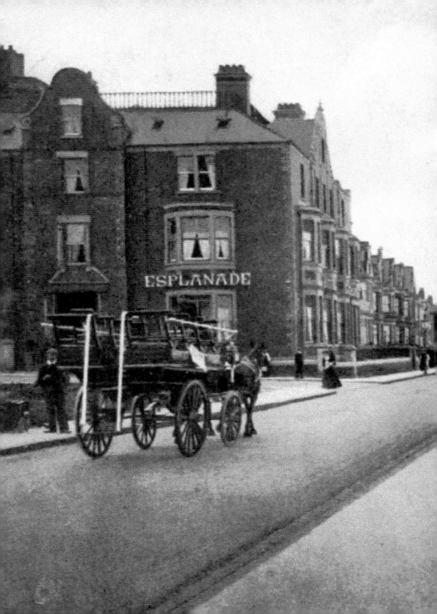

15. THE PROMENADE, *c.* 1908

The Esplanade Hotel, seen here around 1908 on the corner of Esplanade and before the Empire Cinema (later the Alletsa Ballroom) was built opposite in 1910. The steps on the right were known as corkscrew steps, as they spiralled down the cliffs. They were built in 1895 and led down onto the seafront where plans to build a pier had been formulated but never came to fruition.

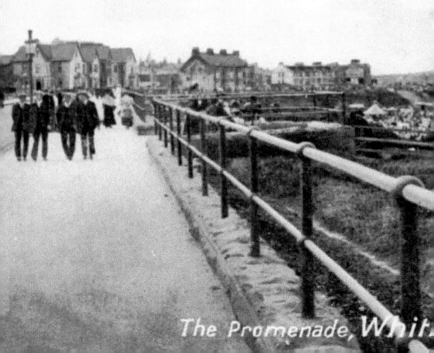

The Promenade, Whit

16. WAVERLEY HOTEL, *c.* 1935

The Waverley Hotel, adjoining the Esplanade Hotel, was originally built as a temperance hotel and opened in June 1907. It expanded over the years, taking in more property, and by the 1920s it had 150 rooms and an impressive ballroom. It became the Rex Hotel in 1937 and still dominates the seafront.

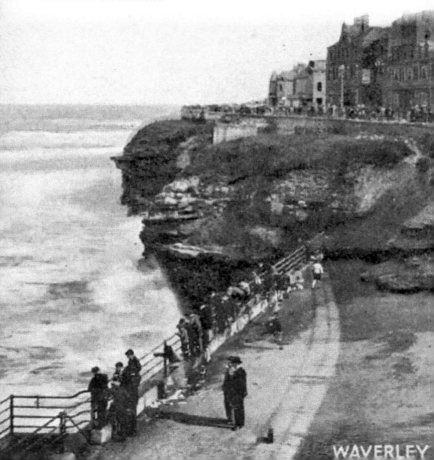

WAVERLEY

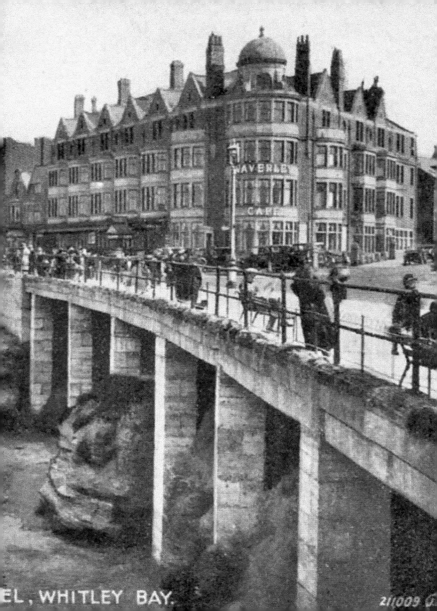

EL, WHITLEY BAY.

211009 G

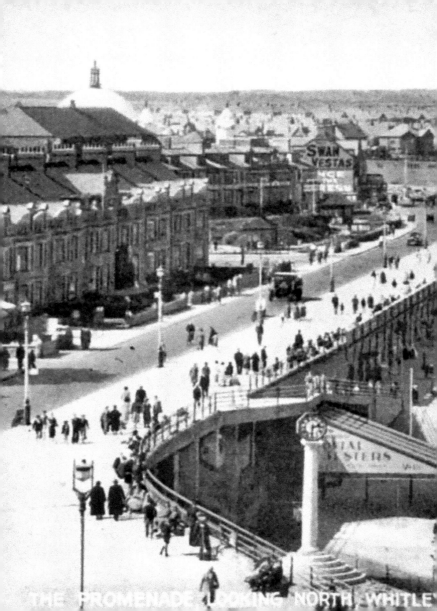

THE PROMENADE LOOKING NORTH, WHITLE

17. THE PROMENADE, *c.* 1935

The recently constructed Central Lower Promenade is seen here around 1935. The sloping building under Gregg's Slope is an open-air theatre that was built in 1930. The clock in the foreground was known as Grant's Clock after the benefactor, James Hamilton Grant. It was referred to as 'a little sister to the lighthouse' when Lady Gregg unveiled it in 1935. Gregg's Café opposite Gregg's Slope was built by Sir Henry Gregg in 1905.

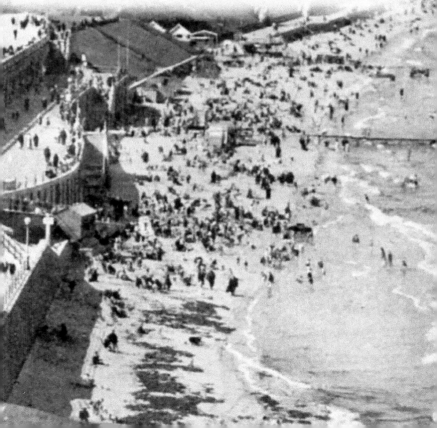

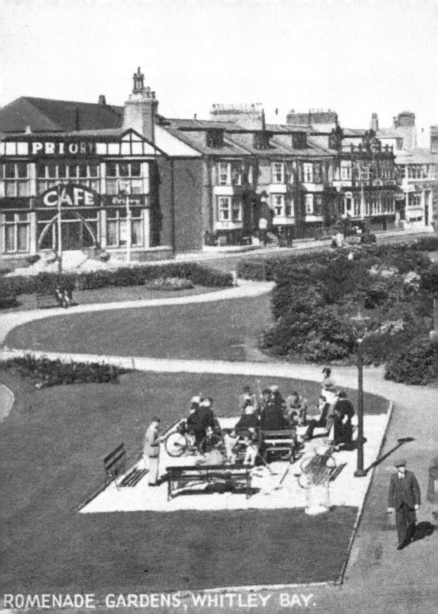

PROMENADE GARDENS, WHITLEY BAY.

18. PROMENADE GARDENS, *c.* 1935

Promenade Gardens were later known as Brook Street Gardens and were overlooked by the Avenue Hotel. In the background is Whitley Park Terrace, which dates back to the 1860s. They were built as five-bedroom houses with coach houses and stables, and many were later converted to commercial premises. The Priory Café stood beside the Priory Theatre.

G.7

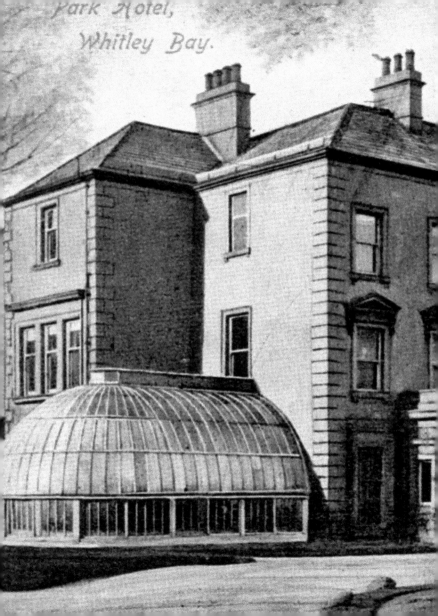

Park Hotel,
Whitley Bay.

19. PARK HOTEL WHITLEY BAY, *c.* 1910

Mr Edward Hall built Whitley Park Hall in 1789 in extensive grounds. The hall was later extended by T. W. Bulman from 1857. In 1879 it was taken over by the Whitley Park Hotel Co., who later developed the grounds into the Spanish City Pleasure Grounds. It was used by the Army during the First World War. The local council bought the property in 1922 and briefly used it as offices. It was demolished in 1939 and the council converted part of the grounds into a park and later built a new library on the site in 1966.

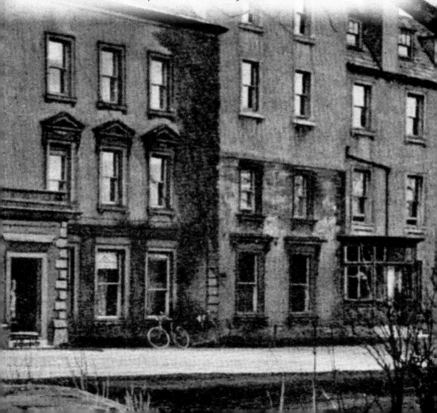

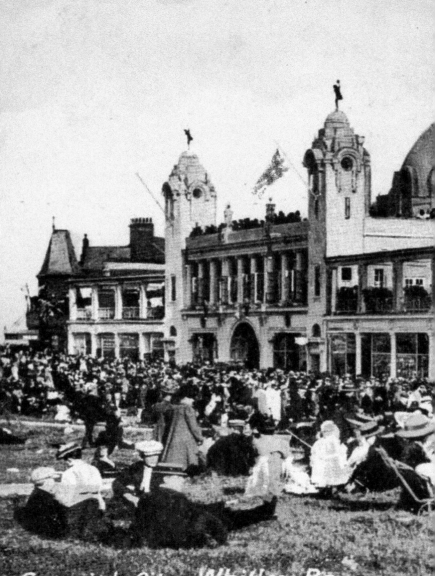

Spanish City, Whitley Bay

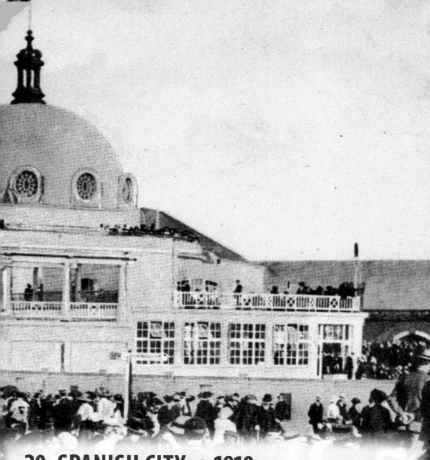

20. SPANISH CITY, c. 1919

The Spanish City Dome, the centrepiece of the Pleasure Gardens, was built to impress. Designed by Newcastle architects Cackett and Burns Dick, and using the latest technology and building materials, it was one of the first structures built using the new Hennebique reinforced-concrete system. It was the second-largest dome in the country after St Paul's Cathedral in London.

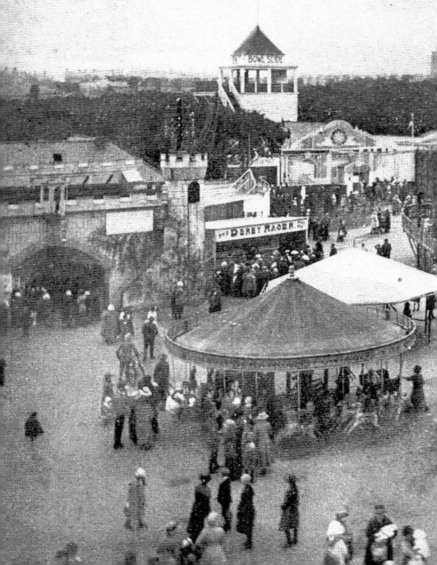

21. SPANISH CITY PLEASURE GARDENS, *c.* 1924

The Spanish City got its name well before the dome was built. The site was developed as an entertainment complex linked to and in the extensive grounds of the Park Hotel. The Spanish theme came from a troupe of toreadors who used to entertain visitors on the site; the company organising summer concerts, Whitley Amusements, built a number of Spanish-style buildings around them as a backcloth to their performances.

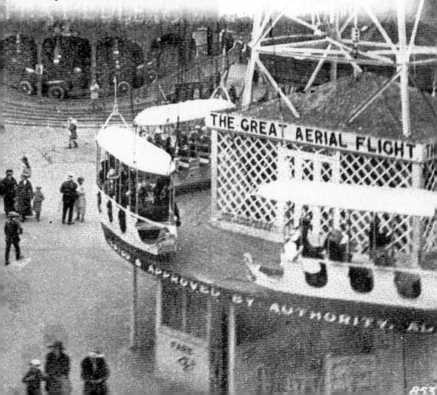

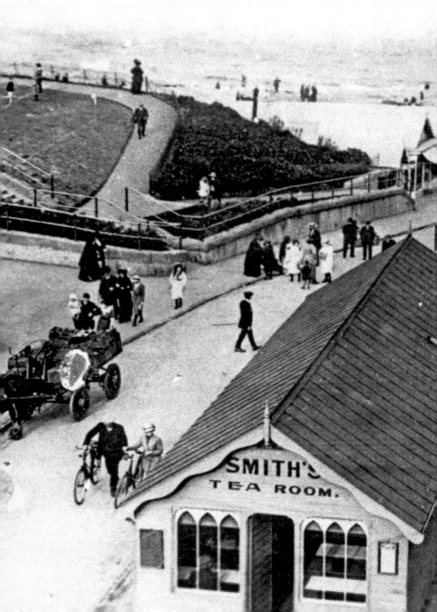

SMITH'S
TEA ROOM.

22. WATTS SLOPE, c. 1914

The view from the Spanish City looks over Smith's Tea Room, built in 1890, down Watts Slope to Watts Café. On the right are the recent public conveniences on Watts Slope and a drinking fountain that had been installed as part of the new promenade, which opened in 1911.

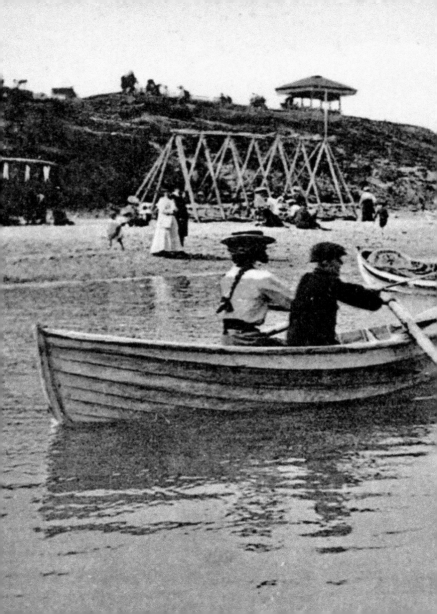

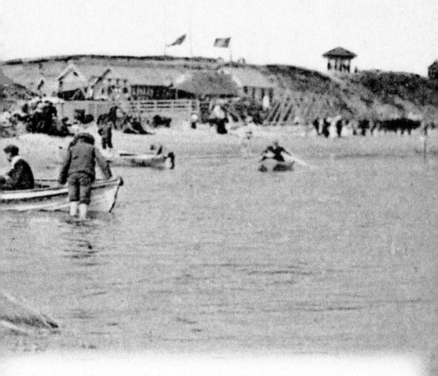

23. BEACH AT WATTS SLOPE, *c.* 1907

Watts Slope and Café were originally developed in 1865 by Andrew Hodgson Watts and Watts Café was run by the family for generations. Rowing boats, 'shuggy boats' (the adult-sized swings), helter-skelters, sandcastle competitions, donkey rides and many more attractions were to be found on the sands to provide entertainment for visitors.

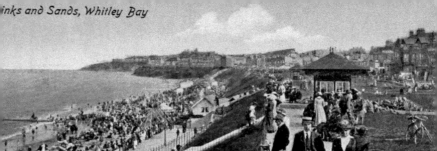

24. LINKS AND NORTHERN PROMENADE, c. 1915

The northern lower promenade was opened in 1914 and extended from Watts Slope to the Panama Dip area and was further extended to Briardene in 1926. The Links were badly despoiled by coal and ironstone mining up until 1882. The Links were also used for grazing cattle and horses by local farmers. It is said the Links were levelled by the Whitley Bay Golf Club, which formed in 1890. A miniature golf course still operates on the Links today.

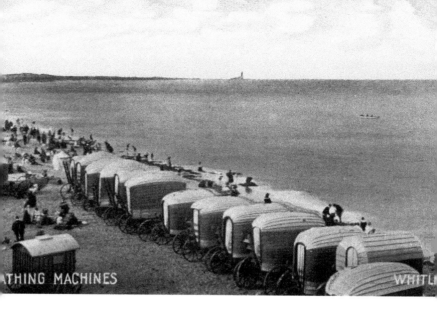

ATHING MACHINES WHITL

25. BATHING MACHINES, *c.* 1905

Bathing machines were first introduced to Whitley Bay around 1870 by John Dunn, who also later provided tents used as changing facilities and tearooms to the seafront. Bathing machines were drawn to the water's edge by horses and ladies could descend into the seawater and get changed again in complete privacy. There were still eighteen in operation in 1911.

STEPHEN FRY, PANAMA HOUSE, WHITLEY BAY

26. PANAMA HOUSE CAFÉ, c. 1909

Panama House Café, seen here around 1909, was owned and developed in 1895 by Stephen Fry, who had been a diver on the Panama Canal. Some claim the central part came from a wrecked vessel named *Panama* and the café did include a lot of nautical features. Stephen Fry died in 1912 and the café was taken over by the council and leased out. It burnt down in 1945 but was replaced by a smaller café later. It survived until the 1990s and the skateboard park is now on the site. The name still lives on in the Panama Dip Gardens and the Panama Swimming Club.

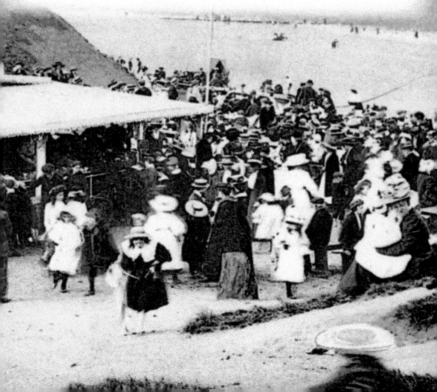

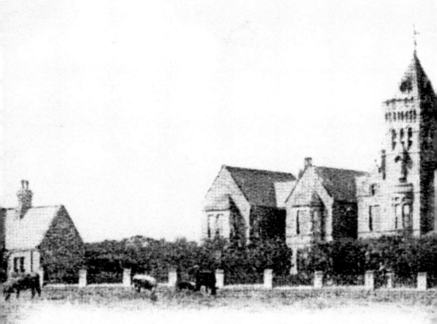

27. PRUDHOE CONVALESCENT HOME, *c.* 1907

The Prudhoe Convalescent Home can be seen here around 1907. It was designed by Thomas Oliver and was built in 1869 following public subscription as a memorial to the 4th Duke of Northumberland (known also as the Baron of Prudhoe Castle), who died in 1865. It was operated by Newcastle Infirmary and the Convalescent Society of Northumberland and Durham. It housed sixty-five male and twenty-five female deserving poor nominated by the charity. It remained open until 1959. A new leisure pool was opened on the site in 1974.

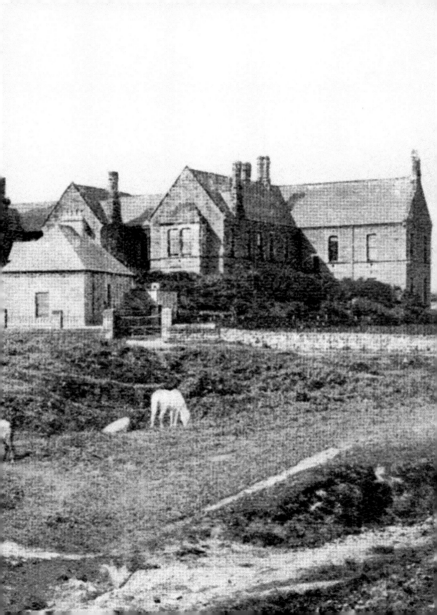

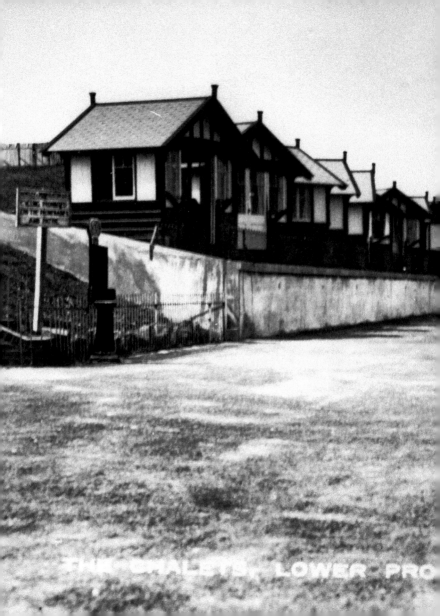

THE CHALETS, LOWER PRO

28. BEACH CHALETS, c. 1938

This view dates from around 1938 and shows the twenty-five original beach chalets built in 1936 by Mr Kirsop and sold to the council that year. They were not used for long and were requisitioned by the wartime authorities when the beaches were out of bounds to the public. They were taken down sometime before 1955 and were eventually replaced in 1959. They survived until 1990 when they were removed. They were designed on wheels that allowed them to move to follow the sun; the metal tracks can still be seen on the bases.

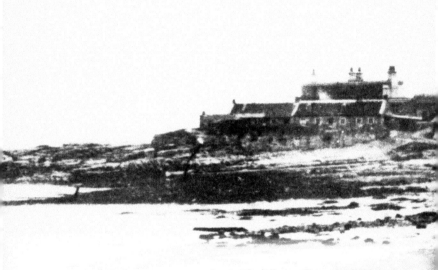

29. ST MARY'S LIGHTHOUSE, 1898

St Mary's Island, also known as Bates Island, was named after St Mary's Chapel that had previously existed on the island. The lighthouse on the island was opened in 1898 to replace the lighthouse at Tynemouth Castle. It was in use until 1984 and was bought by North Tyneside Council in 1986. It has been a popular visitor and education centre since then. In 1862 the Ewen family opened an inn called the Freemasons Arms or Square & Compass on the island. It led to problems with the police and the Ewen's were evicted in 1895 when they fell out with the landowner, Lord Hastings.

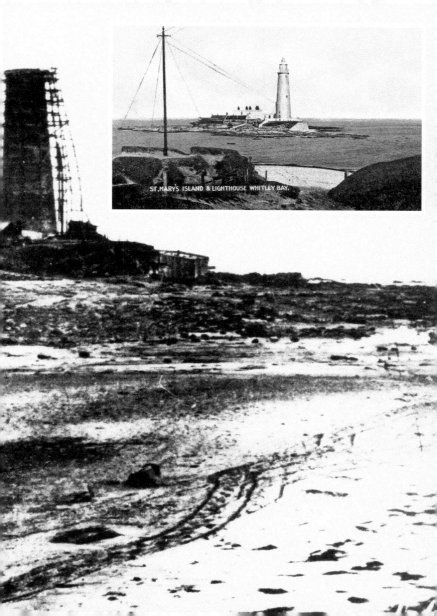

ST. MARY'S ISLAND & LIGHTHOUSE WHITLEY BAY.

30. CARAVAN CLUB OLD HARTLEY, *c.* 1955

The Caravan Club at Hartley has been a long-established site, as seen here in around 1955. Its popularity has not diminished since, as the site affords open views over the coastline, with St Mary's Lighthouse as a major attraction. Behind the site is Fort House, an unusual building built during the First World War and now listed. It was linked to a major underground complex of buildings on the adjoining headland, built as part of the Roberts Battery. The old water tower behind the Delaval Arms is also a reminder of that period.

CARAVAN CLUB SITE, OLD HARTLEY, W

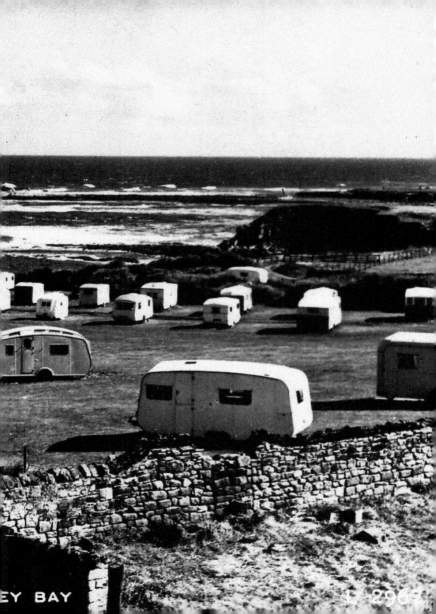

EY BAY

31. OLD HARTLEY, *c.* 1911, LOOKING WEST

The main street of Old Hartley is seen here around 1911, with the village shop in the background. The Delaval Arms is second from the left beside a terrace of buildings including the old Manor House, which is the large building in the centre. The shop was demolished to build the new road between Seaton Sluice and Whitley Bay. East Hartley Farm still occupies the site opposite the Delaval Arms.

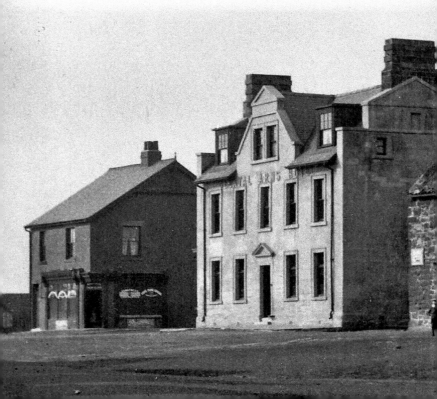

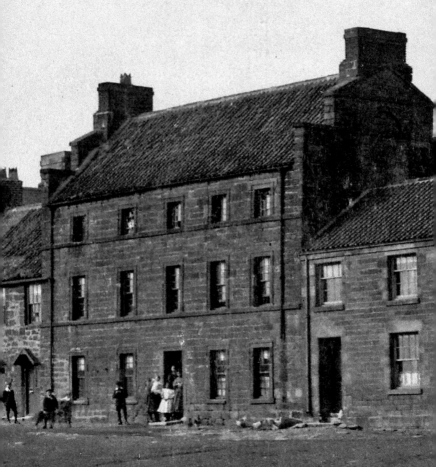

OLD HARTLEY. 441. J.A.H.

32. OLD HARTLEY, *c.* 1930, LOOKING EAST

The village of Old Hartley was essentially a one-street town with buildings either side of the street leading from Hartley Lane up the hill to the Delaval Hotel. This picture is from around 1930 and was taken from the railway line that crossed over Hartley Lane, forming part of the Collywell Bay branch line of the North Eastern Railway. It was constructed before 1914 to serve the potential seaside resort of Seaton Sluice. When the war intervened, the track was removed and eventually the line was abandoned in 1931. The remains of the southern railway bridge abutment can still be seen.

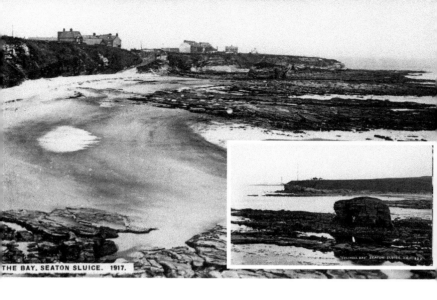

THE BAY, SEATON SLUICE. 1917.

33. COLLYWELL BAY SEATON SLUICE, c. 1917

The headland on the southern side of Collywell Bay is known as Crag Point and once had a building on it called Crag Cottage, an early coastguard station dating from 1832, close to a beacon used by Tyne shipbuilders to test the speed of newly built ships. The sea stack in the bay was known locally as Charley's Garden. It was named after local man Charles Dockwray, who was said to have cultivated the top as a garden for growing vegetables. A major sea wall was built in 1981 to protect the houses on Collywell Bay Road.

34. SEATON SLUICE HARBOUR, c. 1920, LOOKING EAST

Dating from around 1920, this view taken from Seaton Sluice Bridge looks over Sandy Island towards the Cut, separating Rocky Island from the mainland close to the Kings Head Inn. The Cut was constructed in 1764 on the orders of John Hussey Delaval and his brother Thomas to provide an all-weather dock to enable ships to be loaded at all times without being dependant on tides or weather. It was cut out of solid rock and was 270 metres (890 feet) long, 9 metres (30 feet) wide and 15 metres (50 feet) deep. Timbers were installed at either end to keep the water in at low tide. It was last used in 1862 for exporting coal.

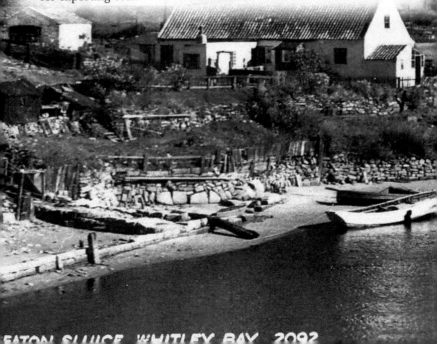

SEATON SLUICE WHITLEY BAY 2092

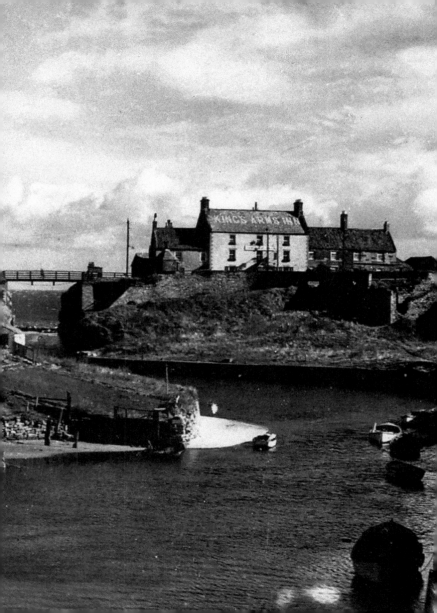

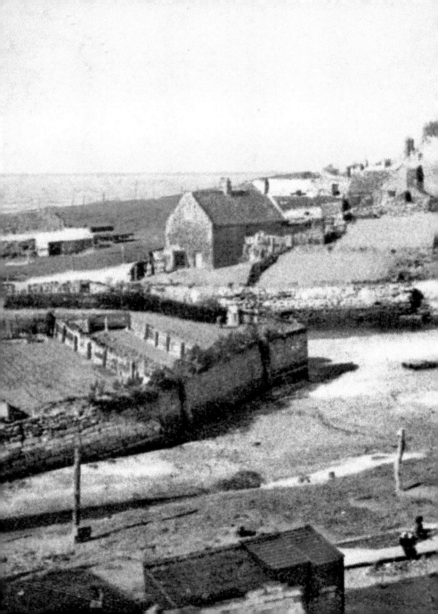

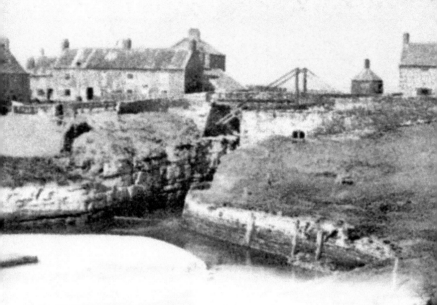

35. ROCKY ISLAND, *c.* 1904, LOOKING NORTH-EAST

Looking north-east across the harbour around 1904 towards Rocky Island, the Kings Arms Inn is on the top right beside the Pilot's House, with the swing bridge over the Cut beyond. In the 1901 census there were sixteen cottages on Rocky Island with sixty-three residents, whose occupations included coal miner, hawker of fish, coastguard, tailor, teacher and blacksmith. All the houses except Coastguard Cottages were demolished in the late 1950s.

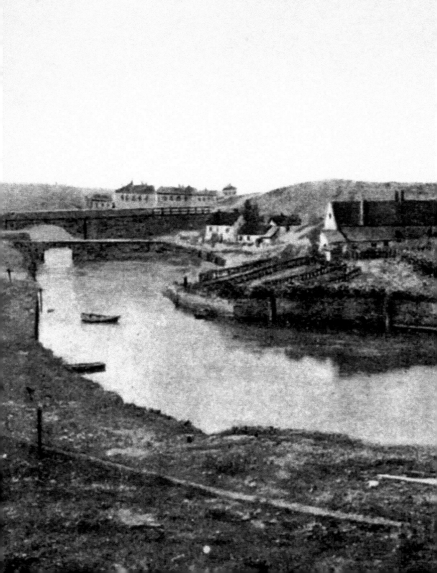

36. SEATON SLUICE HARBOUR, 1906, LOOKING NORTH-WEST

Two bridges can be seen crossing the Seaton Burn; the nearer lower bridge is the oldest bridge, dating back to the 1700s, and the higher bridge was built in 1894. The cottages beside the old bridge on Sandy Island were occupied by the Crane family before they were demolished around 1908. The raised areas behind are the ballast hills made up from ships' ballast (chalk, sand and flint) deposited on the land over the years before the ships were loaded with coal.

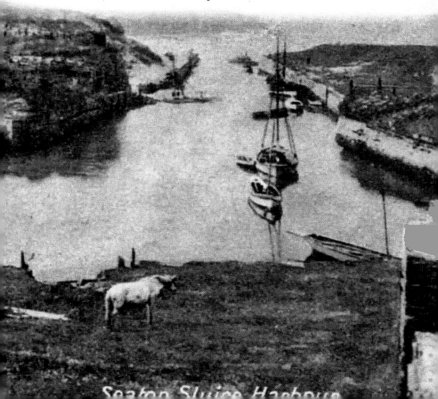

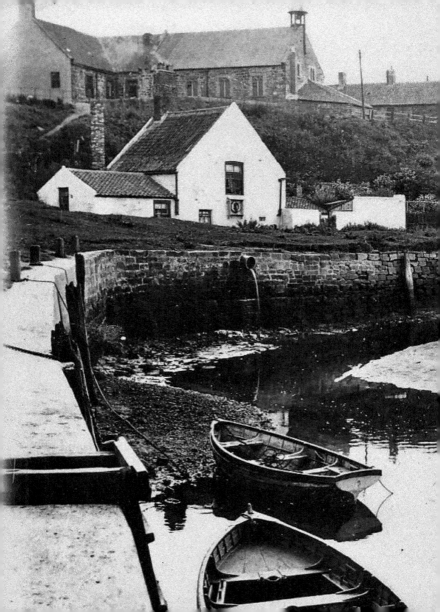

37. SEATON SLUICE HARBOUR, *c.* 1940, LOOKING SOUTH-WEST

John Willie Gibson's house is on the low level. The spire above is from the original St Paul's Church. This was a remarkable building and was built before 1800 as a brewery. When it fell out of use, the back part was converted in the 1850s to be used by the Wesleyans. In 1870 the front part facing the harbour became St Paul's Church of England. The building was demolished in 1962 and the former Ochiltree Hall, built in 1914 in memory of John Ochiltree, became St Paul's Church. The terraces on the right were built on part of Glasshouse Square.

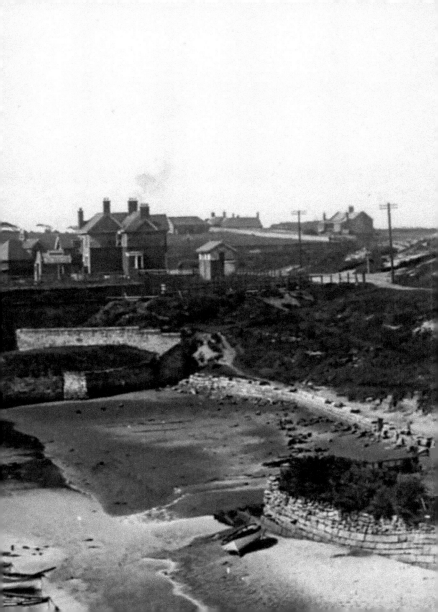

38. SEATON SLUICE HARBOUR, *c.* 1920, LOOKING NORTH-WEST

This view is from around 1920 and shows the new Melton Constable pub, built around 1908, in the distance beyond the bridge. The former cottages in the foreground were still occupied at this time on Sandy Island, which technically is not really an island. The harbour was originally known as Hartley Pans when it was being used to produce salt using salt pans, in which salt water was boiled using a coal fire under the metal pan. Salt was exported from the harbour for many years together with coal, copperas and later bottles.

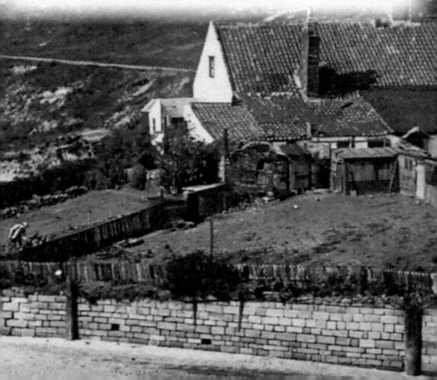

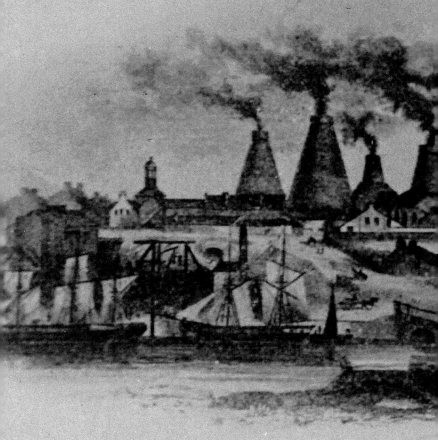

Seato

OLD BOTTLE WORKS.

39. SEATON SLUICE BOTTLE WORKS, 1850, LOOKING SOUTH

The engineer Thomas Delaval and his brother, Lord John Delaval, developed the Royal Hartley Bottle Works from 1763 to take advantage of the available materials close to the site, namely coal, sea sand, kelp and clay. The works, glasshouses and storage cellars were linked to the harbour by a system of underground tunnels and waggonways. 'Bottle Sloops' were used to transport bottles from the harbour. To supply ships using the new harbour Lord Delaval also opened a small shipbuilding yard on the Sandy Island side of the harbour, which closed before 1812.

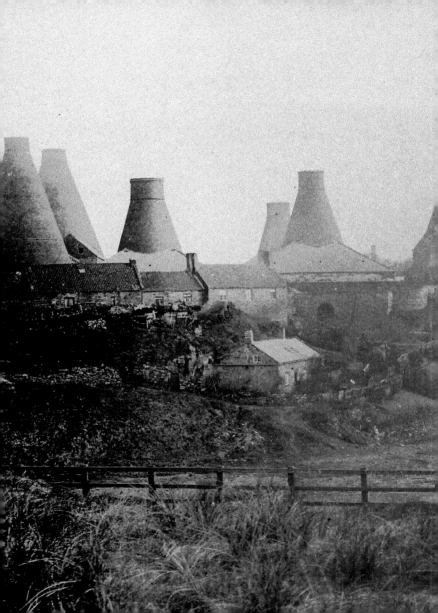

40. SEATON SLUICE BOTTLE WORKS, *c.* 1895, LOOKING SOUTH

Between 1764 and 1788 six large cones were built and were all given a name: Success, Waterford, Byas, Gallaghan, Charlotte and Hartley. The works closed in 1870 and the cones were demolished in 1896. The bottle works, known as 'The City', were situated on the south side of the Seaton Burn to the west of the bridge on the land now occupied by St Paul's Church and Ryton and Bywell terraces. The housing and glasshouse offices nearby were built around an area known as Glasshouse Square.

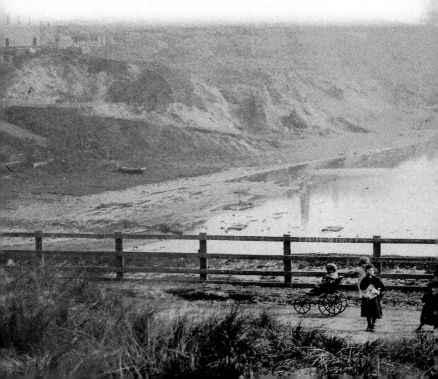

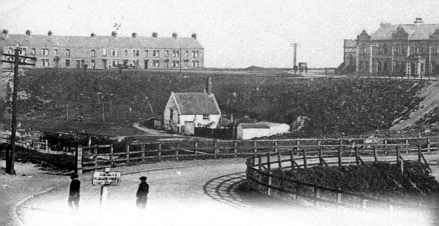

41. BRIDGE BEFORE 1922, LOOKING SOUTH-EAST

The bridge built in 1894 is shown here before 1922. The spire of St Paul's Church can be seen beyond the bridge. Beyond that is the Waterford Arms Hotel dating from 1899.The buildings to the right of the church were all built on the site of the former Glasshouse Square between 1897 and 1922. West Terrace was also built during this period to replace the former terrace called Irish Row, to the south of the Kings Arms Inn.

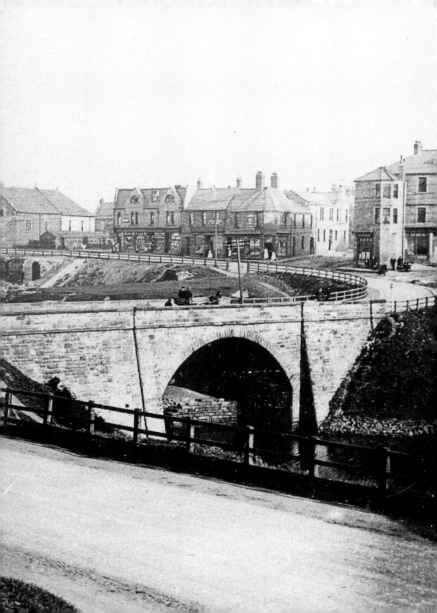

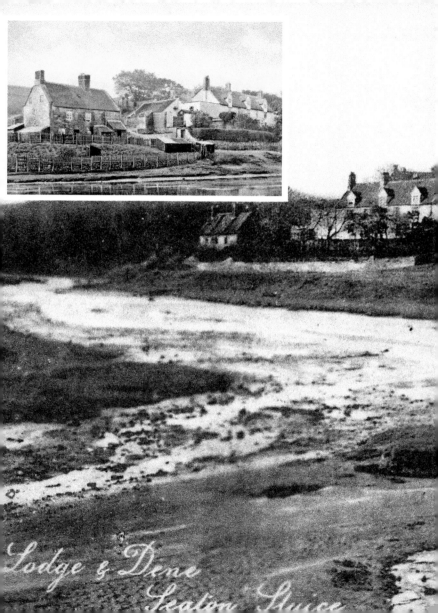

Lodge & Dene
Seaton Sluice

42. SEATON LODGE, HOLYWELL DENE, c. 1920, LOOKING NORTH-WEST

This view from around 1920 is taken from just over the bridge on the north side looking west towards Holywell Dene over the floodplain of the Seaton Burn. The white building to the right of the two eighteenth-century cottages, which remain today, is Seaton Lodge. It was built in 1670 by Thomas Harwood, a master mariner, and was a large Jacobean-style house with a thatched roof. It was bought by Sir Ralph Delaval in 1674, who later moved out of his mansion house on the estate to live at Seaton Lodge in 1685. It was demolished in the 1960s.

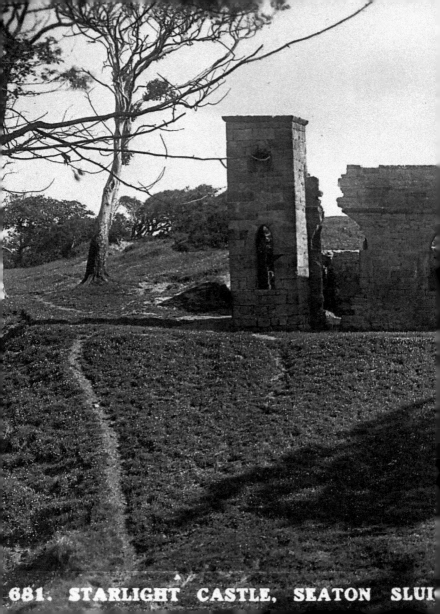

681. STARLIGHT CASTLE, SEATON SLUI

43. STARLIGHT CASTLE,
HOLYWELL DENE, *c.* 1920

Starlight Castle, seen here around 1920, was a folly built in the 1760s by Sir Francis Blake Delaval to win a bet of 100 guineas from his friend, the playwright Samuel Foot. To win the bet the castle had to be built in twenty-four hours – hence the name Starlight Castle, as it was built by the light of the stars. Sir Francis had arranged for a lot of it to be made in advance but it was erected within the time and someone slept in it the following night. It was lived in until 1874. It has declined in size over the years and now only part of one tower remains.

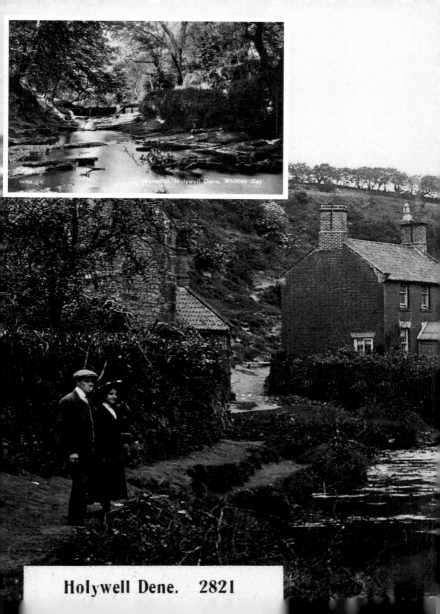

Waterfall, Holywell Dene, Whitley Bay

Holywell Dene. 2821

44. HARTLEY MILL, HOLYWELL DENE, *c.* 1920

The couple are standing in front of Hartley Corn Mill (1760–1920), partially hidden by the trees, with the mill cottages beyond. Today the only evidence to be seen on site is part of the mill's rear wall, which is built into the bankside below a footpath leading up to Hartley West Farm. The stepping stones over the burn also survive. There was a long mill race cut into the bank side to feed water to the mill, and this followed the north bank of the burn from a dam built close to the waterfall upstream. Over 200 people once lived in Holywell Dene.

45. SEATON DELAVAL HALL *c.* 1910, LOOKING SOUTH

Seaton Delaval Hall, viewed in around 1910, was built between 1718 and 1728 for Admiral George Delaval as a palace for his retirement and was designed by John Vanbrugh. Sadly neither lived to see the hall completed as Admiral George fell off his horse and was killed in 1723; Vanbrugh died in 1726. The hall was inherited by Sir George's nephew, Captain Francis Delaval, who completed it. The National Trust has owned the hall since 2009 and in 2011 the *Antiques Roadshow* visited the site.

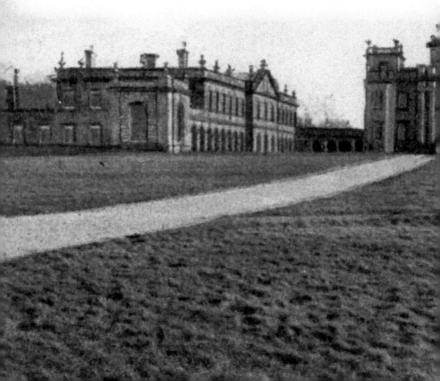

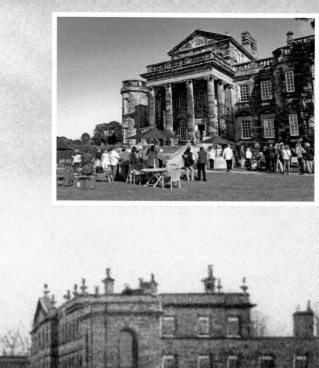
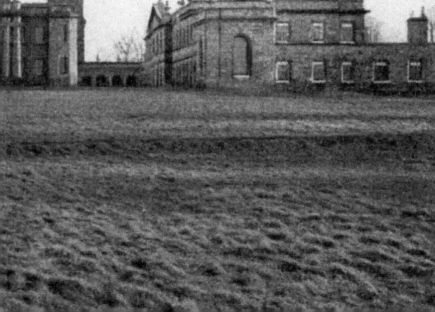

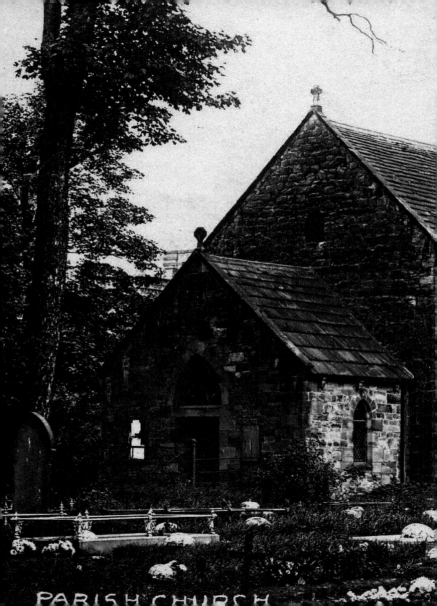

PARISH CHURCH

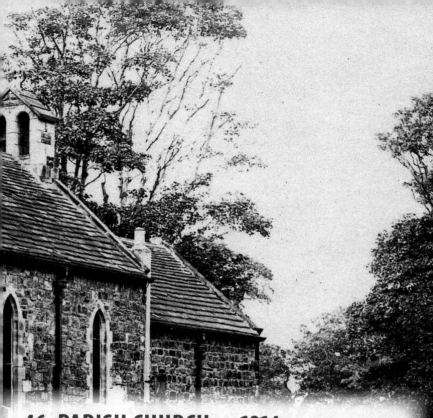

46. PARISH CHURCH, *c.* 1914

The Church of Our Lady, seen here around 1914, was built in 1102 as a
private church for Hubert de Laval (Delaval) close to an earlier castle
of which no remains can be seen. The family had originally come
to England with William the Conqueror and were given land in the
north east. The church became the parish church in 1891 and remains
so. It is independent of Seaton Delaval Hall. The building remains
little altered since it was built in the Norman fashion, apart from the
addition of a porch on the western end in 1895.

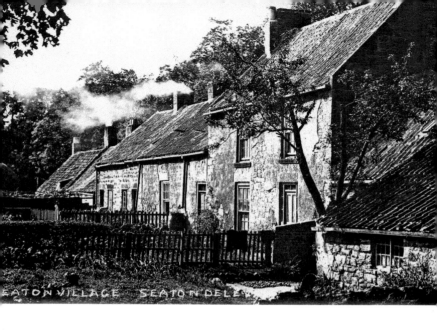

EATON VILLAGE SEATON DELE...

47. SEATON VILLAGE, *c.* 1930

Seaton village was an ancient village thought to date from Saxon times and was situated immediately west of the Church of Our Lady and Seaton Delaval Hall to the north of the present Seaton Village Farm. It was comprised of two terraces of cottages with a large pond to the south. The western terrace was in existence on the 1857 Ordnance Survey map but had disappeared by the 1897 map. The eastern terrace, demolished in 1959, is pictured here.

ACKNOWLEDGEMENTS

Special thanks go to Joyce Marti and Martyn Hurst for their help and encouragement and other staff at the local studies section of North Tyneside Libraries for allowing me to use many of the photographs from their collection, which they have built up since 1974. Many of the photos used have been donated by members of the public and library staff are always on the lookout for additional pictures to add to their collection and to be made available to a wider audience through books like this. Most of the information for this book came from books and materials held by the local studies section.

Another very good source for information is the website of both the Seaton Sluice and Old Hartley Local History Society (who meet every second Tuesday of the month in Seaton Sluice), and Friends of Holywell Dene (who meet on a regular basis). Both groups are full of enthusiasts of the local area and are they are keen to welcome new members and visitors as well as wanting to hear from anyone who has memories or pictures of the area.

Thanks go to staff at Amberley Publishing for asking me to write the book and for their help in producing it. Thanks to my wife Pauline for proofreading the text.

Again many thanks go to my family – Pauline, Peter, Sue, David and my granddaughter Isla – and to my friends for their continued encouragement and support.

ABOUT THE AUTHOR

I was asked to write this book following the success of similar books such as *Newastle History Tour* in 2017, *Tynemouth & Cullercoats History Tour* in 2016, *Wallsend History Tour* in 2015, *Whitley Bay & Seaton Sluice Through Time* in 2013, *Tynemouth and Cullercoats Through Time* in 2011 and *Wallsend Through Time* in 2009. I worked for North Tyneside Council for over twenty-nine years as a town planner, and knew Whitley Bay very well. I have also lived in Monkseaton, part of Whitley Bay, for over twenty-seven years. In retirement I have been a volunteer at Seaton Delaval Hall and have got to know Seaton Sluice well, as it was developed by the Deleval family, who lived at the hall. I am also a Newcastle city guide and have led walks around Whitley Bay on behalf of the guides as well as Tynemouth, Cullercoats, North Shields and Wallsend – see www.newcastlecityguides.org.uk for details of current tours.

The pictures are arranged to follow a scenic walking route along the coastline between Whitley Bay and Seaton Sluice, starting at Whitley Bay and ending at Seaton Delaval Hall.

As with any book of this type, there will inevitably be some errors for which I apologise in advance as I have not been able to check every name, date or detail at the original source.